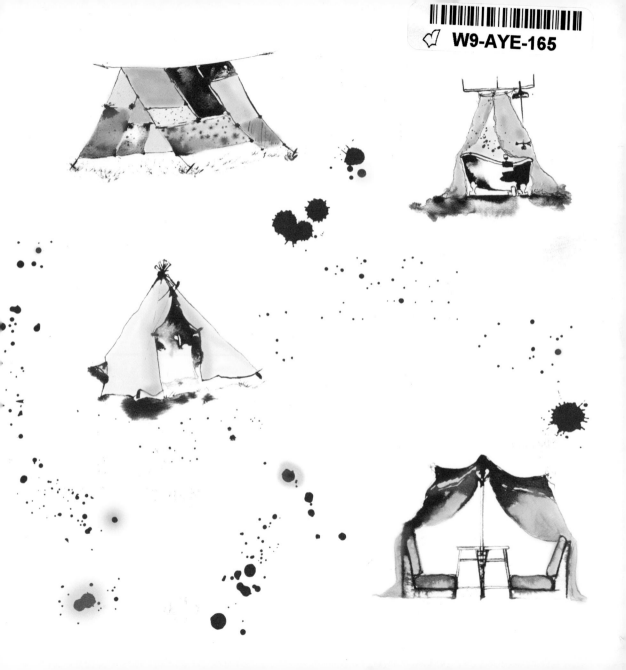

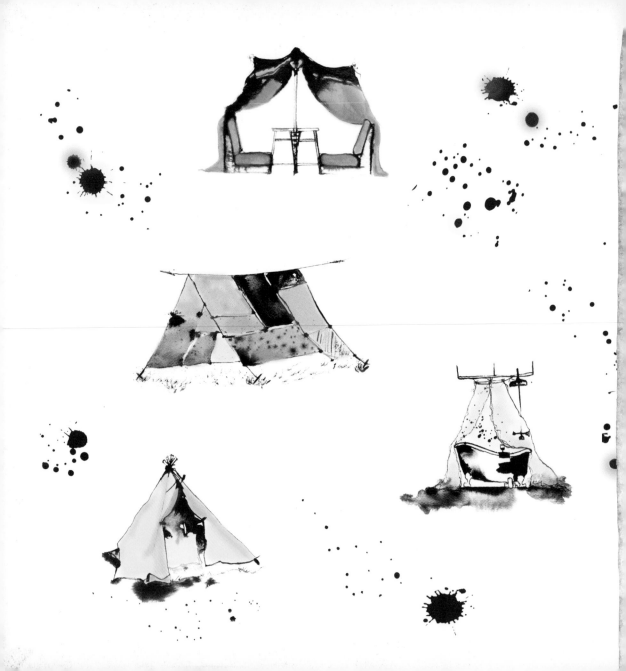

Blanket
FORT

GROWING UP IS OPTIONAL

Grackle + Pigeon

MORROW GIFT · An Imprint of WILLIAM MORROW

HarperCollins books may be purchased for educational,
business, or sales promotional use. For information, please email
the Special Markets Department at SPsales@harpercollins.com.

FIRST EDITION

WM Morrow Gift is a trademark of HarperCollins.

Designed by Bonni Leon-Berman

Grateful acknowledgment is made for permission
to reproduce the following:

A Good Nook, artwork by Jessie T. Kressen

Yoga Fort, artwork by Fluidtoons — Brett W. Thompson
Appears Courtesy of Gamba Forest

Meditation Fort, artwork by Heather Keton
Appears Courtesy of Gamba Forest

Library of Congress Cataloging-in-Publication Data
has been applied for.

ISBN 978-0-06-274275-9

18 19 20 21 22 LSC 10 9 8 7 6 5 4 3 2 1

This book is dedicated to our
friends and family,
and everyone out there who keeps
a healthy dose of childlike wonder.

C O N T E N T S

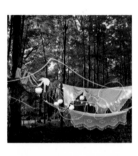

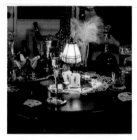
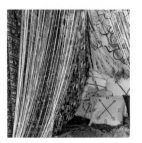
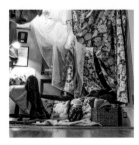
IV

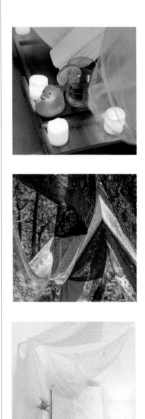

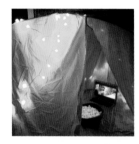

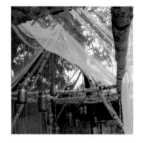

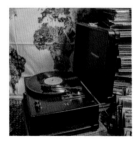

V

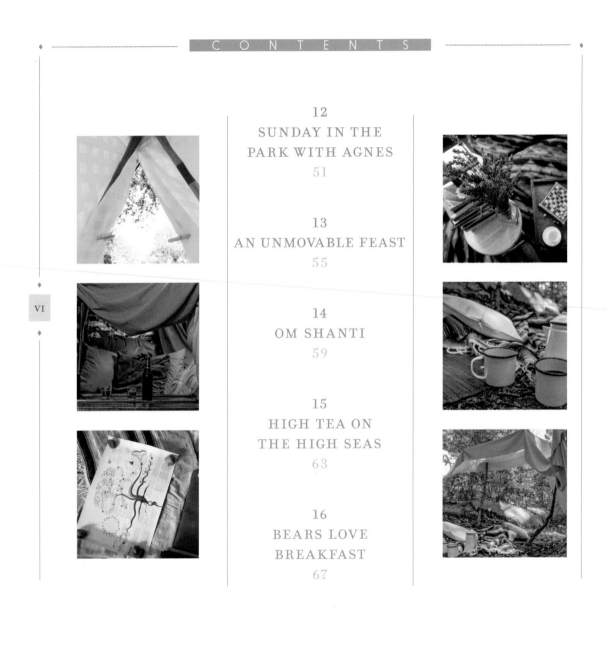

VI

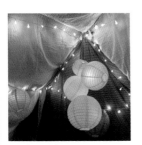

VII

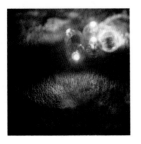

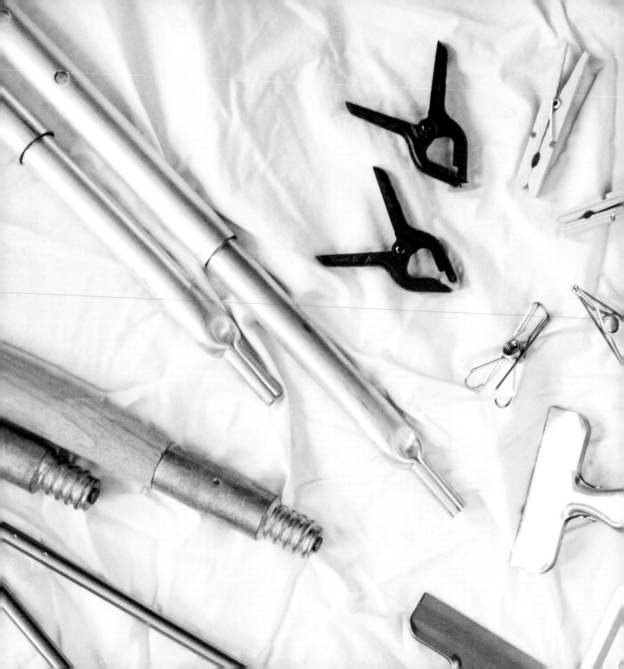

*L*et's face it—adulting is hard. Gone are the days when life's biggest worry was getting caught breaking curfew. Nowadays, if you stay up late, you feel awful the next day. Come on, body. Get with the program. We are adventurous young spirits ready to take the world by storm.

Not going to lie. Ambition is exhausting. Bed cuddles are awesome. Can't we just not deal for a while and take refuge in a pile of pillows and blankets and maybe, just maybe, redefine what adulting actually means?

We are Grackle + Pigeon, and we're all about getting creative visions airborne. As a husband-and-wife artistic team, we've collaborated across print, multimedia, and live performance—and now, we are so stoked to bring you twenty-plus variations on the pinnacle of all things awesome: blanket forts.

Still with us? Let's do this.

In this book, you have both a road map and outright permission to escape your everyday obligations. Some blanket forts can be built using common household items, others require a bit of research and invention. Some require many hands, and some you can build yourself. We give you the basic steps and bare bones of a plan to get started, but our main intention is to activate your imagination so you can build your own vision.

Welcome to our world. Here, there are no deliverables and there are no deadlines. Growing up is optional.

The Essentials

While we're huge proponents of diving in headfirst and asking questions later, we're going to recommend purchasing some rope, some twine, and an abundance of clips and clamps before you get started. These items can all be sourced cheaply and figure into every fort you're likely to build.

You should also procure two aluminum rod tent poles online. You'll notice that we used broom handles, an eight-foot dowel, telescoping (non-bendy) tent poles, and tree trunks in the creation of this book. We'll tell you right now, though: nothing compares to aluminum rod tent poles in terms of flexibility and ease of use. When it comes to creating the base structure of your fort, these offer the greatest number of options in terms of sizes and shapes,

and are lightweight and compactible, which makes them easy to transport.

So far as knots are concerned, we've included some guidance where tying the right knot will help you take your fort construction from A-plus to A-plus-plus. Otherwise, we recommend a healthy disregard paired with impromptu innovation.

Last, leave modesty to the other parts of your life and locate some out-there fabrics and props. These are blanket forts, after all. Fortune favors the bold (patterns).

What You'll Need

- Different kinds of clips
 - clothespins (metal, plastic, wood)
 - mini clamps
 - curtain clips with hooks
 - binder clips or other large metal clips
- Rope
- Twine
- Fishing line
- Telescoping tent poles
- Aluminum rod tent poles
- Broom handles
- string lights
- Penny nails
- Command (sticky) hooks
- Outdoor decking screws
- Lots of blankets, sheets, fabrics, pillows, and throws
- An imagination

Aluminum Rod Tent Pole Tutorial

Aluminum rod tent poles are easy to use, lightweight, and compactible. Simply unfold and fit the pieces together. An elastic rope extends inside the length of the pole to help keep the pieces in place.

Draping

Draping technique should be flexible, depending on the look you're trying to achieve.

For most blanket forts, you'll want to create a base structure and toss the fabric over once it's secure. In these cases, it helps to have two people, one to toss and the other to catch. You may need to tug back and forth to get the fabric to hang evenly and to place the opening where you want it.

Every now and then, for a more free-floating appearance, you might want to hang fabric from the underside of ropes using clips. For examples of this, see Head Space (p. 33) and Bears Love Breakfast (p. 67).

Securing

Our personal opinion? Use as many clips as your heart desires. Large metal clamps help secure heavier fabrics in place, while small clips give you freedom to finesse the final shape.

The knots you'll need can be split into two camps: those with the ability to slide (for example, a Taut Line Hitch) and those used to secure objects firmly in place (a Square Knot).

You'll want to use a knot that can slide when securing the uprights of your construction to fixed anchor points such as a doorjamb or wall, in order to tighten or slacken the ropes as needed. An example of this can be seen in RPG OMG (p. 71). Separately, this type of knot can also be used to create a clothesline to serve as the backbone of your fort, as seen in Wild Things (p. 27).

Taut Line Hitch (aka Slip Knot)

1. Loop rope around an anchor object and hold one end of the rope taut (referenced below as the standing line).
2. Coil the other end twice around the standing line, working back toward the anchor object.
3. Make one additional coil around the standing line on the outside of the coils just made.
4. Tighten the knot and slide it on the standing line to adjust tension.

You'll want to use firmly fixed knots when elements of your fort construction need to be bound in place, solid as a rock, such as in Urban Mystic (p. 5), where the uprights are secured to the bed frame. One option is a Square Knot. Before tying off the final knot, though, be sure to tightly wrap the rope around, across, and between every cross section of the objects you need to secure together. For an example, see High Tea on the High Seas (p. 63), where the center mast pole is secured to two stools. (You get points for safety, not aesthetics.)

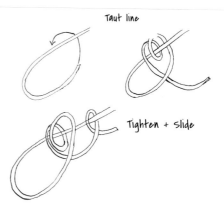

Taut line

Tighten + slide

Square Knot

1. Tie the two ends of rope as though starting to tie your shoe, then again in the opposite direction. Pull taut.
2. Each end of rope should exit the knot in the same direction as it originated.

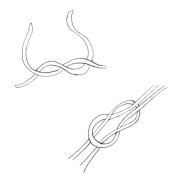

cat fun

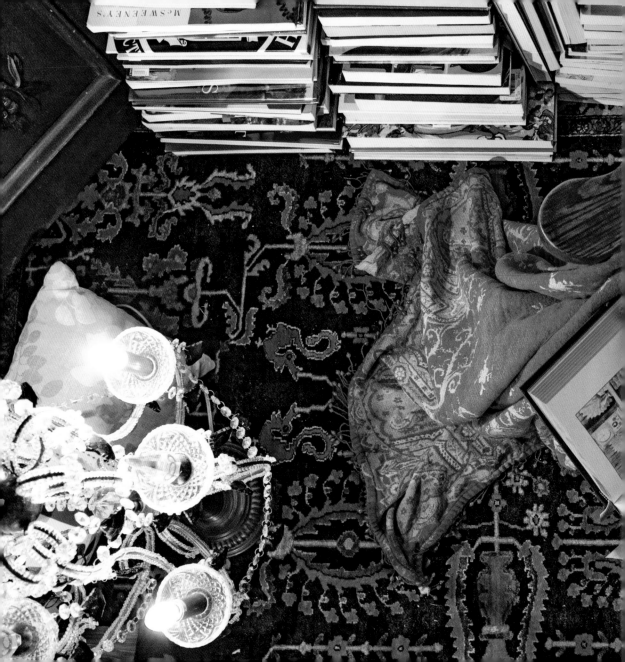

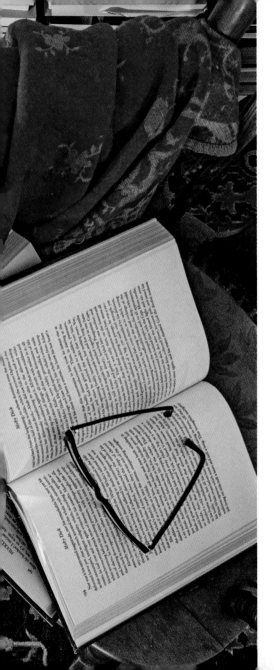

1

A
Good
NOOK

YEAH, WE STILL READ PAPER BOOKS

What a fantastical world this author's created. What colorful characters. Even the scent of these old pages gives a sense of calm and possibility. And what's this? Another plot twist? Imma lie down and see what happens next.

Tips + Tricks

This one's all about creating a book cave, so the ideal spot would be a tight corner of your home where you can stack your favorite novels all the way to the ceiling. In order to get the shape we created, you may need to stick some penny nails in the walls to hang curtains. We suggest white blankets to keep things bright.

What You Need

A tight corner or nook in your home

Blankets, sheets, pillows
Penny nails or sticky hooks

Rope or twine, clamps, clips, clothespins

What to Include

All your favorite books
Art prints and souvenirs

Your favorite chair
Rugs

Reading lamp
Reading glasses

Directions

1. In your nook, secure blankets to the walls on three sides with penny nails or sticky hooks.
2. Hang the "ceiling" blanket overhead by clipping its corners to the same nails or hooks.
3. Run rope along the front opening of the fort and clip the ceiling blanket to the middle of the rope.

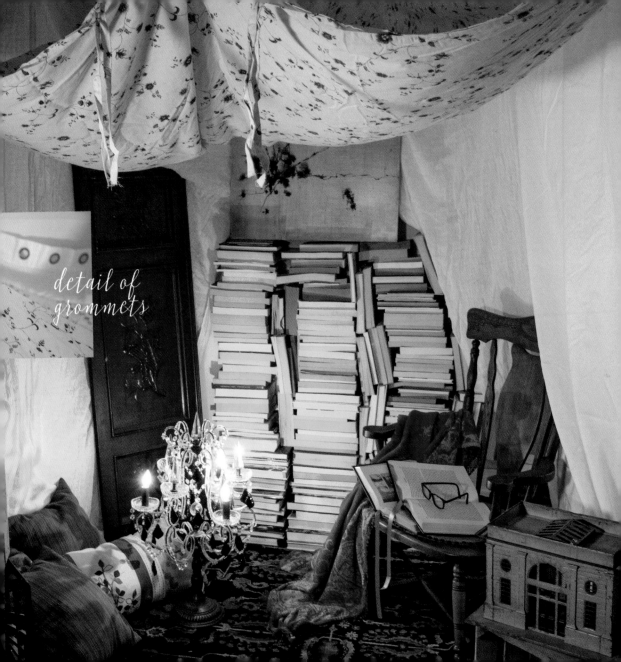

detail of grommets

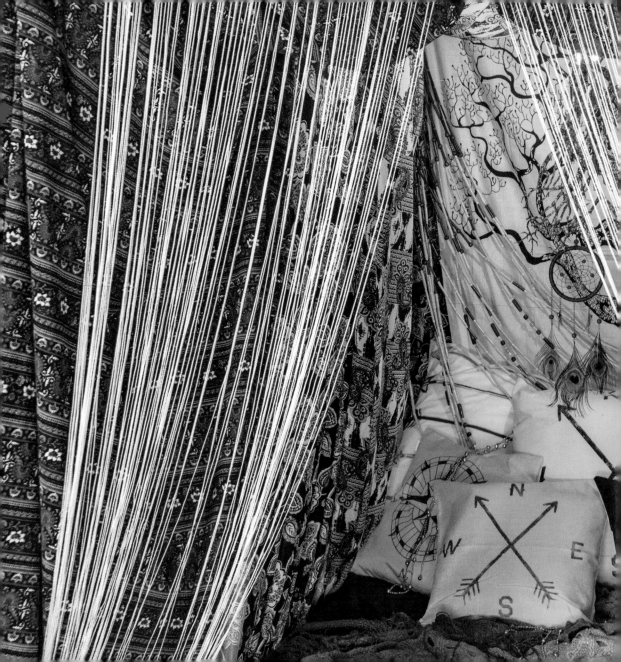

Urban
MYSTIC

WHERE DREAMS TAKE FLIGHT

Does your idea of royalty involve napping like woodland mammals? This one's for you. Source those artisanal branches. Hang 'em proud from your homemade lofted canopy. Pair with a dreamcatcher and drift, drift, drift off into hibernation. No need to plan ahead for winter. This fort's made for creature comforts.

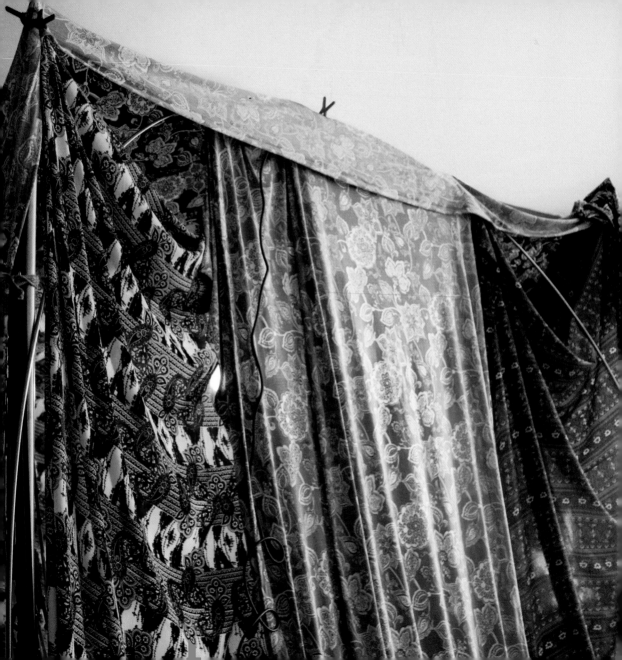

Tips + Tricks

This is one of the more complicated forts to build, but the results are well worth it. You're basically creating a canopy bed out of two different kinds of tent poles. First, tie the telescoping (non-bendy) tent poles to the four corners of your bed and extend them to full height. It helps if you have a bed frame for sturdiness. Then position the aluminum rod (bendy) tent poles so they arch over the long sides of the bed—adjusting the height to match that of the telescoping tent poles by unlinking pieces as needed—and also tie them to the bottom corners of the bed. Double-check that everything is secured before continuing. Run a rope across the center of the bed to connect the aluminum rod tent poles at their highest points—this will be used to hang a bare-bulb light source, dream catcher, and whatever other artful items you choose to set the scene. Drape one long panel of fabric over the top of your structure, then fill in the sides with additional lengths of fabric. Clip a beaded curtain or something similar over the foot of the bed and part in the middle to create a beautiful entryway.

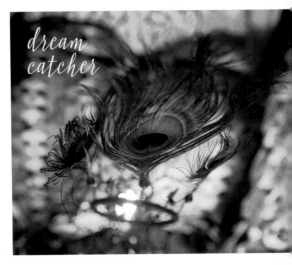

dream catcher

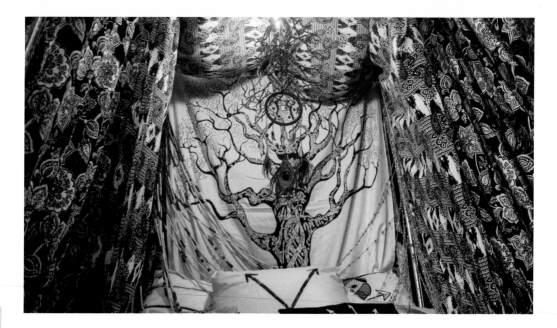

What You Need

Four telescoping tent poles

Bed (ideally with a bed frame)

Two aluminum rod tent poles

Rope or twine, clamps, clips, clothespins

Bare-bulb light source (use an extension cord if needed)

Blankets, sheets

What to Include

Dream catcher

Branches and other woodsy details

Mug of mead

Copious amounts of pillows

Jethro Tull music playing in the background

Directions

1. Tie the telescoping tent poles to the four corners of the bed, then extend them.
2. Secure the aluminum rod tent poles along the sides of the bed.
3. Tie a rope line between the top points of the aluminum rod tent poles to hang the light source.
4. Drape a blanket over the top of the structure.
5. Fill in the sides with sheets and fabric, securing at the top with clips.
6. Using clips and clamps, create a doorway and structure fabrics as desired.

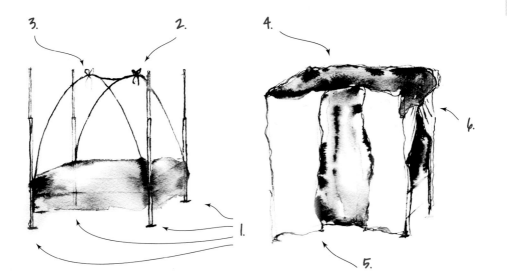

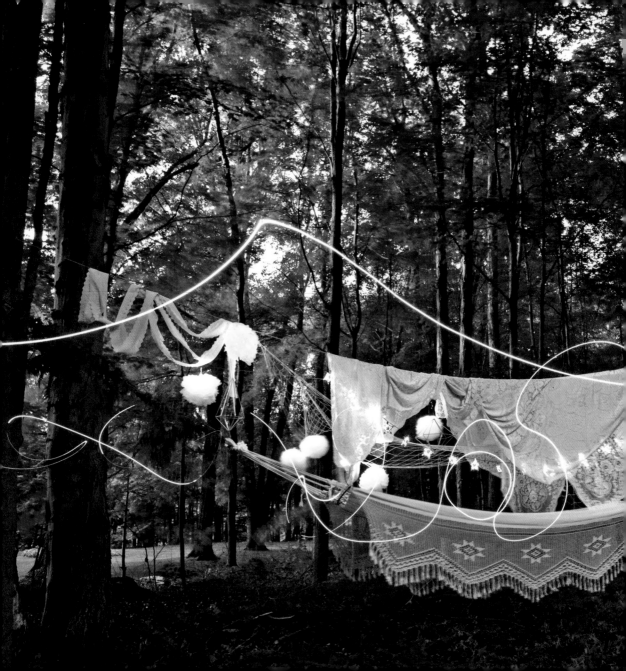

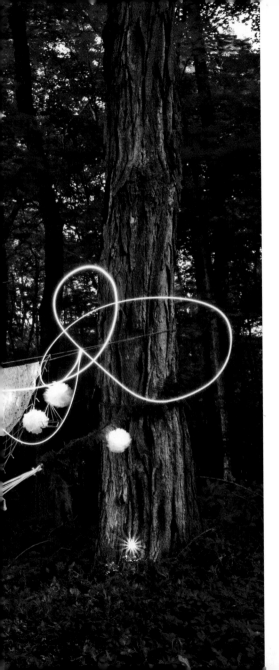

3
Fireflies
+
FAIRY TALES

WHO SAYS MAGIC ISN'T REAL?

No backyard is complete without a healthy dose of make-believe. Dig up your favorite kid's book, hop on a hammock, and fly back to the land of lost boys and pirates, ticking crocodiles and fairies with the voice of a bell. Can't find your shadow? No matter. All you have to do is clap your hands and believe. (Some assembly required.)

Tips + Tricks

First, invest in a really good hammock. You'll need two trees set approximately ten feet apart to hang it from. It's best if there is another tree directly beside one of the hammock trees so you can string a rope in a triangle shape around all three to support a lacy shade or roof. Keep your rope high on the trunks to allow maximum space for draping. Make a visit to Grandma's linen closet and grab all the vintage lace tablecloths you can find. We used balloon lights and solar-powered string lights to give this fort that beautiful dusky glow.

What You Need

Hammock

Trees

Rope or twine, fishing line, clamps, clips, clothespins

Lace tablecloths

White or cream-colored fabric

Netting

Paper craft puff-balls or lanterns

Balloon lights

Solar-powered string lights

What to Include

Ferns and branches gathered from the woods

Camera with a slow shutter to capture fairies in flight

A healthy imagination

Directions

1. Hang a hammock between two trees.
2. Tie a rope between the same two trees as well as a third tree to create a triangle above the hammock.
3. Drape layers of the lace table-cloths, netting, and fabric over the rope.
4. Use fishing line to hang tissue paper pom-poms at varying heights. Hide balloon lights inside.
5. Hang solar-powered string lights.

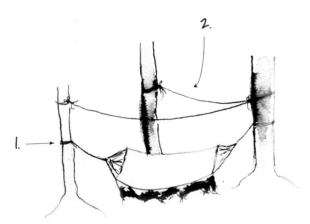

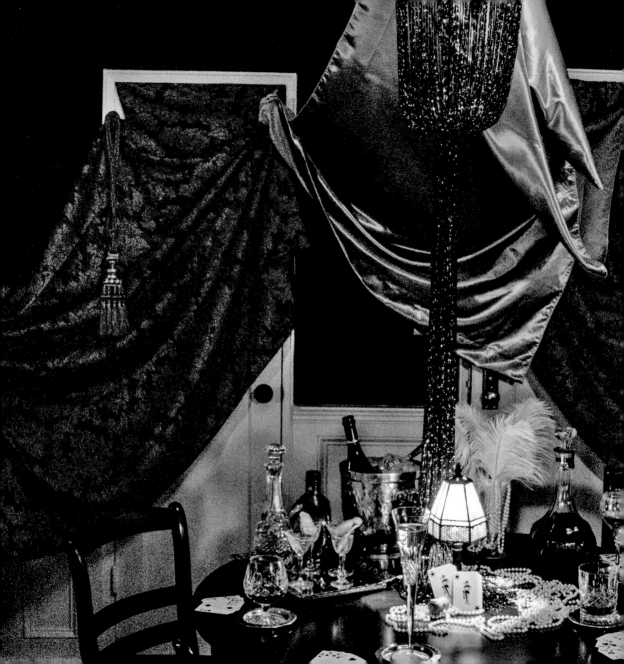

4

What's THE PASSWORD?

CHOOSE WHO GETS INTO YOUR OWN PRIVATE COCKTAIL LOUNGE

Boulevardier. Gimlet. Daiquiri. Martini. Negroni. Sidecar. Vieux Carré. Gin fizz. Pisco sour. Planter's punch. Last Word. Whatever your poison, stir, shake, and sample in style.

This one is all about bringing together as many vintage elements as possible. It's less about making a fort to crawl inside, and more about draping silk and satin and tassels around your room until it feels like a basement speakeasy. Invest the time to find a classy tabletop lamp—as your primary light source, it's crucial to set the scene. Stir, shake, and sample in style.

What You Need

One ultra-stylish tassel curtain

Rope or twine, clamps, clips, clothespins

Silk or satin sheets, fabric

Art Deco everything

What to Include

Booze

Mismatched glassware

Feathers

Pearls

Playing cards

Gramophone

Directions

1. Tie a tassel curtain around an overhead light fixture.
2. Use clips to hook sheets onto the fixture—make sure it's sturdy!
3. Tie sheets to the wall, using rope to create attachment points if they don't reach.
4. Adjust where the clips are attached to drape fabric into desired shape.

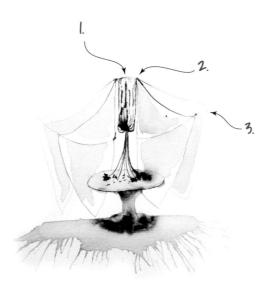

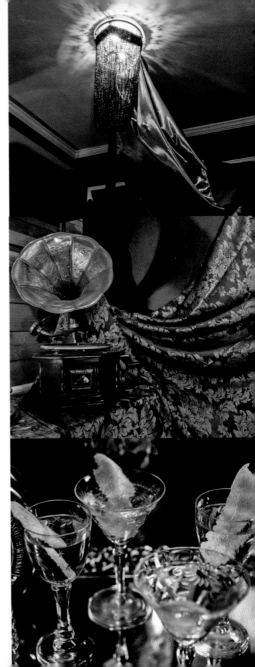

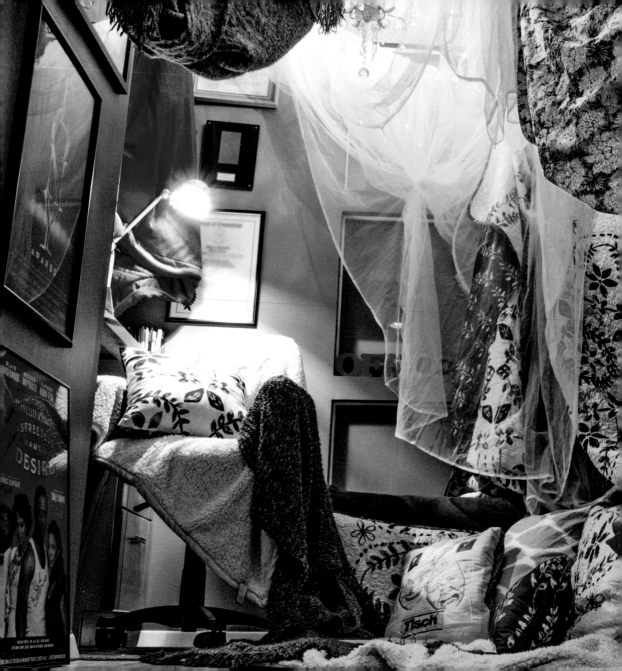

Office
SPACE

WORKING FROM HOME JUST GOT MUCH LESS ADULT

Call with senior management? I'm on it. Last-minute change to the presentation? Check your inbox. Factory closure in China? I'll see what I can do. I'm your magical unicorn consultant. I don't complain, and I don't need benefits. You may never see my face but I. Will. Deliver. Enjoy your fluorescent lights. It's 4:30 P.M., and I'm in pj's.

Tips + Tricks

This home office had a great light fixture, so we decided to use it as the focal point to make a really cozy nook. We used throw pillows from around the house to create a theatrical, drapey, unconstructed vibe. The last thing you want to be is Type A about your surroundings, so create a setting that'll keep you sane while you're dealing with those last-minute requests.

What You Need

Home office	Rope or twine, clamps, clips, clothespins	Blankets, sheets, curtains, and pillows
Sticky hooks or penny nails		

What to Include

Task list	Wi-Fi	Hyper-organized office supplies
Ergonomic chair	Caffeine	

Directions

1. In your office, connect rope from a center light fixture or ceiling hook to sticky hooks or penny nails on the walls.
2. Loosely drape lightweight sheets, curtains, and cozy blankets on the rope for a deconstructed look.
3. Fill with pillows. Lots of pillows. Why should it feel like work?

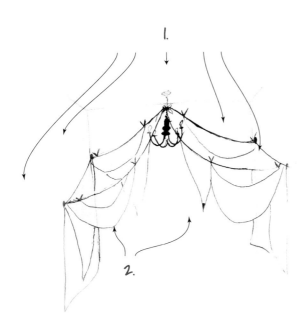

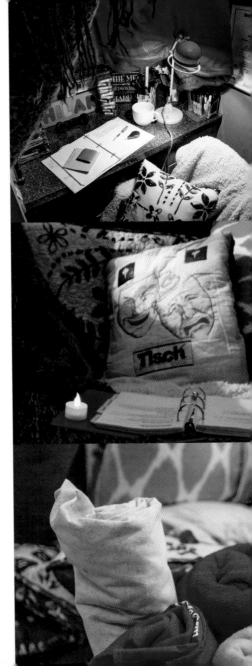

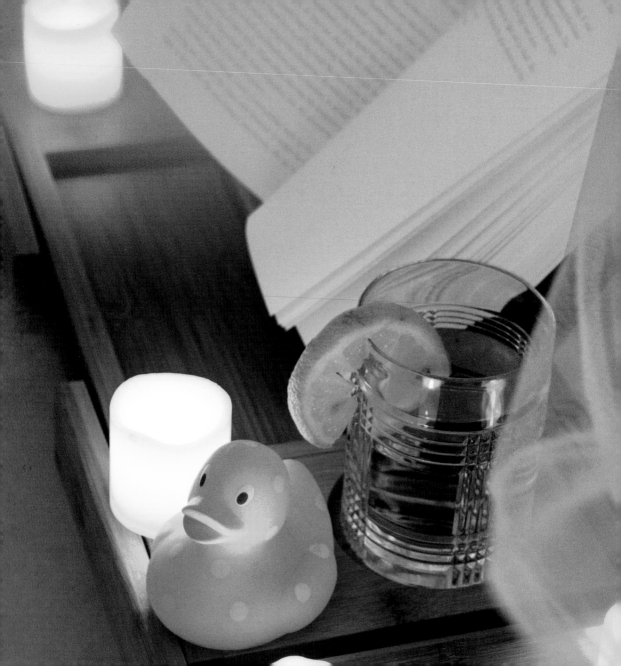

Bath CUDDLES

GET YOUR CLEANSE ON

You know the scene. Pick any movie where a couple either discovers their true feelings or reignites a years-long romance. One returns home to unexpectedly find their remarkably uncluttered bathroom decked out in candles and the most attractive bubble bath ever. For your creation, why not take it one step further and lasso

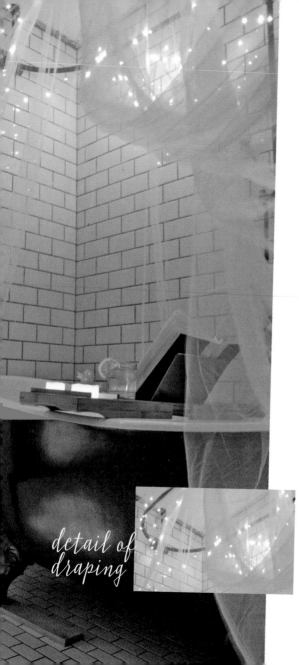

detail of draping

the stars? Even if you're single, it's going to be a steamy night.

Tips + Tricks

This one's easy. All you need is one of those premade mesh canopies from your local department store (also easily found online). It's lightweight enough that you can pretty much secure it to anything in your bath or shower. We love the twinkle lights in this one—just make sure to keep them away from the water elements. It's best to get battery-operated lights so you don't have to plug them in. Warm-glow LED candles are ideal for this setup. Hold off filling the tub until everything's set up, and use a stepladder and no-slip shower pad (and your best judgment) to avoid slipping as you climb around decorating your bathroom.

Premade mesh canopy or mosquito netting

Bathtub

Battery-operated string lights

Rope or twine, clamps, clips, clothespins

Bath salts and oils

LED candles (Canopies and fire don't mix!)

Adjustable tray table

A good book

Rubber ducky (ours is named Mortimer)

Ice water with lemon slices

Directions

1. Secure the canopy or netting to the bathtub's shower curtain rail.
2. Add some lights, making sure they're secure and away from the water.
3. Drape the canopy outward from the bathtub and connect to the room's features using twine and clips to create the desired shape.

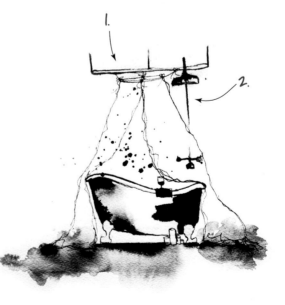

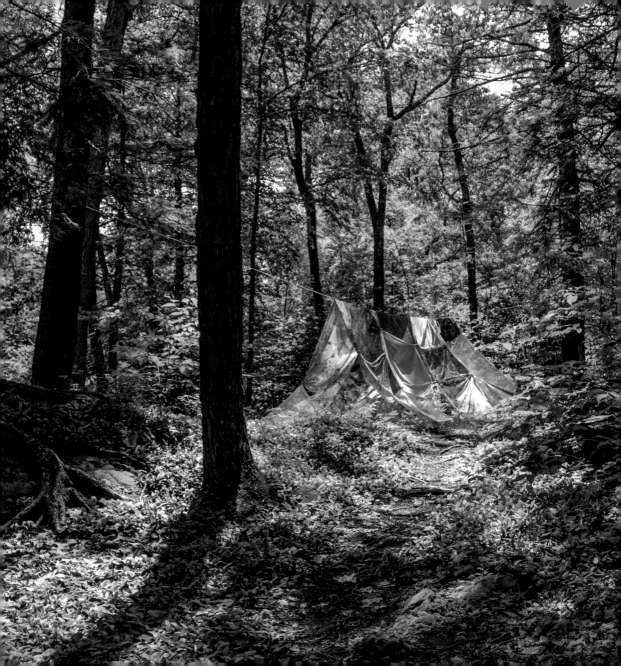

Wild THINGS

THE BOHEMIAN PARADISE YOU'VE ALWAYS WANTED

Calling all flower children: This is your moment. Pack your bags. Hop in your Subaru. Flee to the mountains and find a grove to call your own. Start a sing-along with the wind. Watch the colors dance. Many woodland creatures are vegans, too, so you'll have plenty to talk about. Might be wise to

pick up a book on plants you're better off not eating. Nothing deadlier than a bad batch of mushrooms.

Tips + Tricks

Find two sturdy trees and tie a rope between them, specifically using a slip knot on one or both ends so you can raise everything once the blankets are in place. Make a giant sheet of cloth by tying together the corners of whatever mystical fabrics you can find—scarves, tablecloths, curtains, scraps. Toss the newly formed sheet over the rope, raise it up, and stake the corners. We got some waterproof rugs and layered them to have a nice surface to lounge on.

What You Need

Killer campsite with trees	Colorful fabric scraps, scarves, sheets	Waterproof rugs
Rope or twine, clamps, clips, clothespins		Pillows

What to Include

Free spirit	Rosé	Journal
	Yoga pants	

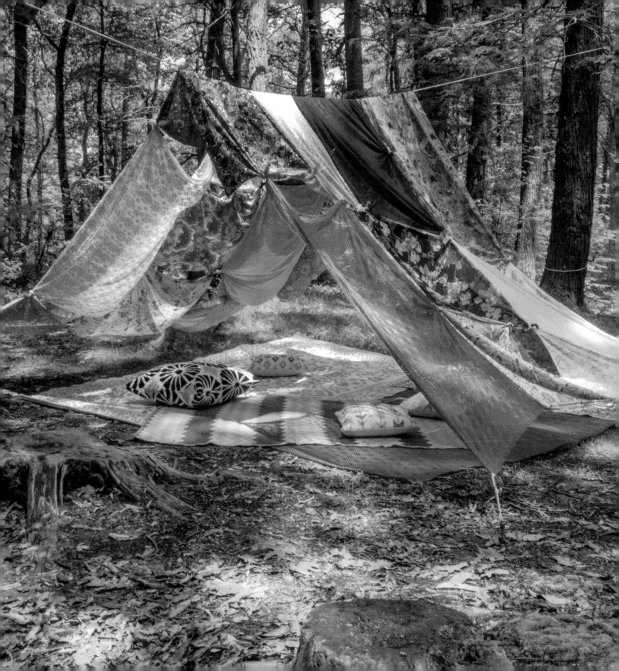

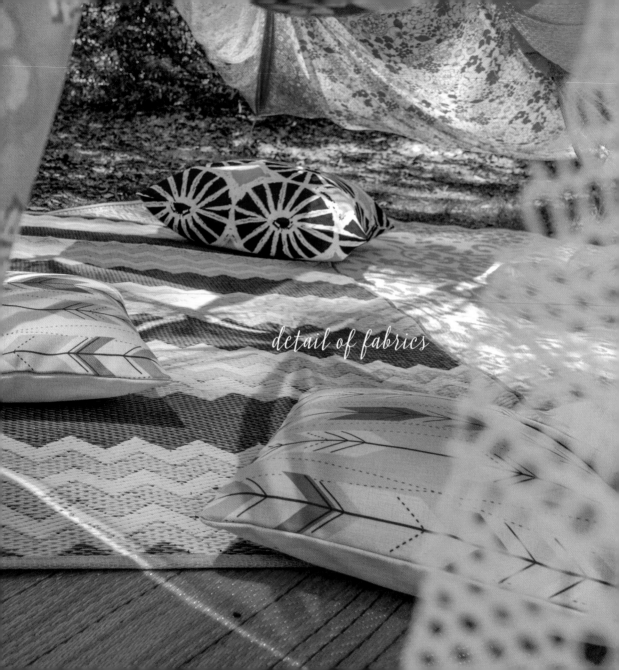

detail of fabrics

Directions

1. At your campsite, run a rope between two trees and lay waterproof rugs on the ground below.
2. Tie the fabric scraps, scarves, and sheets together.
3. Drape the newly created fabric panel over the rope.
4. Attach short lengths of rope to each corner, pull out, and stake.
5. Scatter pillows at will.

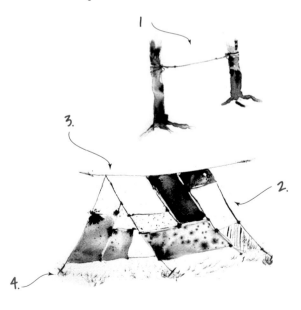

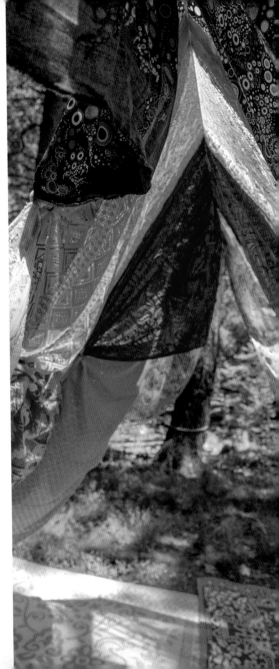

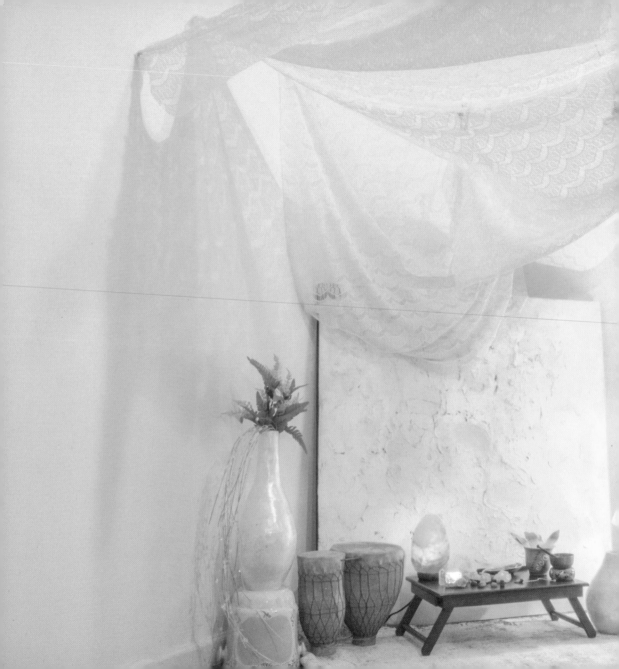

8

Head SPACE

LIKE NOISE-CANCELING HEADPHONES, BUT FOR YOUR SOUL

Focus on your breath. Empty your mind. Acknowledge thoughts as they appear, then let them float away. Feel yourself floating. There's nothing you have to do. There's nothing you have to accomplish. Give yourself permis-

sion to be here. Congratulate yourself on making the time. Every minute is a miracle. Every breath is a gift.

Tips + Tricks

If you're not precious about your walls, use pushpins and screw eyes as we did to get this lovely layered effect. It's best if you position them haphazardly, choose a light fabric like lace or voile, and install clips at various points until you get the desired look. Don't overcomplicate—it's a meditation fort, after all.

What You Need

A quiet, out-of-the-way spot	Rope or twine, clamps, clips, clothespins	Pushpins and/or screw eyes
	Light, translucent fabric	Walls you don't mind puncturing with tiny holes

What to Include

Great light	A soft surface to sit on	Whatever aids your practice: crystals, smudge sticks, incense, or empowering objects
	Small table or altar	

Directions

1. Secure ropes to the walls with pushpins or screw eyes.
2. Tie or clip the ropes to different points in the fabric.
3. Adjust where the clips are attached to drape the fabric into desired shape.
4. Secure a rope to the front and pull out for more cover.

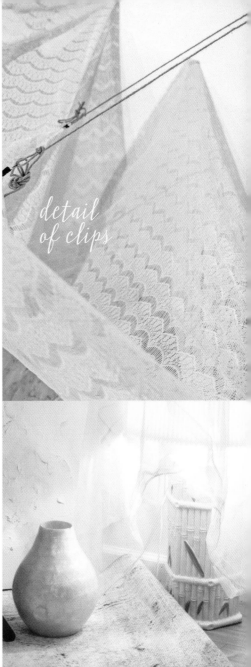

detail of clips

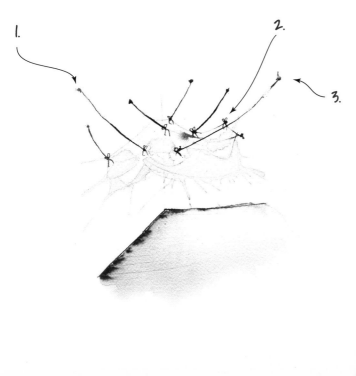

1.

2.

3.

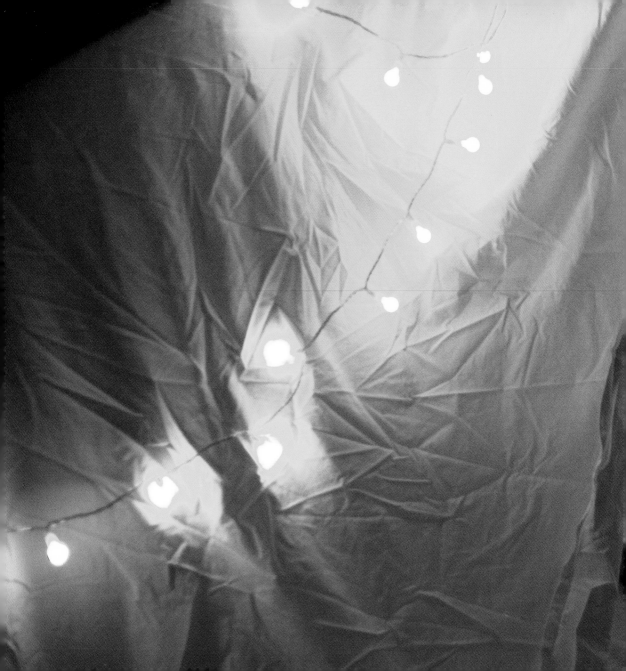

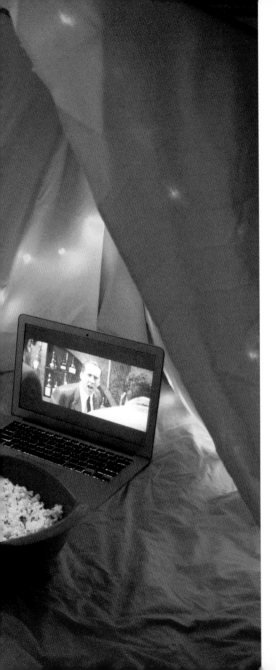

Un Petit FILM

"AM I GETTING THROUGH TO YOU, ALVA?"

"Can I be real a second? It's not often
that you meet somebody who…"

"Likes Nicolas Cage movies?"

"He's an artist."

"I know. If you wanted to . . ."

"Yeah?"

"We could go watch a Nicolas Cage
movie at my place."

Tips + Tricks

This one's for that special someone you're willing to share your popcorn with. Simply tie the aluminum rod tent poles to the corners of your bed, crossing them in a standard tent construction and tying them together in the middle. Throw some sheets over the top and scatter string lights. It helps if you have some comfy comforters to begin with. A robust assortment of Nicolas Cage masterpieces is available to stream online—though nothing beats owning them on DVD, Blu-ray, LaserDisc, and VHS.

What You Need

Rope or twine, clamps, clips, clothespins

Two aluminum rod tent poles
Bed (ideally with bed frame)

Blankets, sheets, pillows
String lights

What to Include

Laptop

Popcorn

Vampire's Kiss T-shirt

Directions

1. Tie the tent poles to the corners of the bed, crossing in the middle like for a tent.
2. Tie the poles together at the center.
3. Drape fabric over the top. Use clips to create an opening. Fill with pillows.
4. Scatter string lights over the fabric to make it glow!

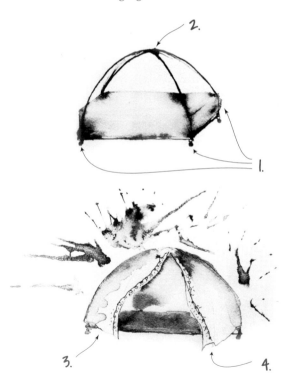

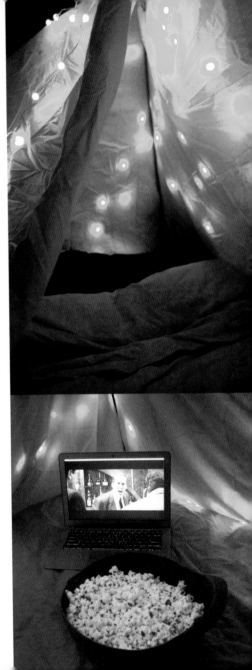

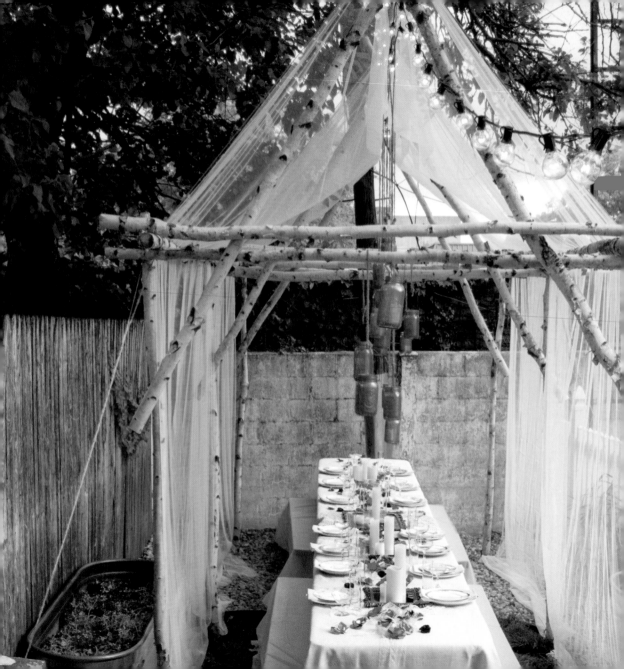

Garden PARTY

SOMETIMES YOU HAVE TO GO ALL OUT

Your friends are shiny happy people, and they love you. Why not set a color palette, send an invite, break out the tools, and host a potluck worthy of a magazine photo spread? Need a specialty cocktail? We've got you covered. Multiply the recipe to maximize the fun. Fair warning: It might be a long night.

Tips + Tricks

This one requires some construction skills. We ordered a bunch of birch poles from Etsy and did some research on picnic shelter construction. The result was something simple and sturdy enough that it actually lasted us all summer (a raccoon ended up using it as a jungle gym). Make sure you use outdoor decking screws as they resist the elements. For safety's sake, if you don't have any carpentry experience, it's best to find a friend who does and is willing to stand on top of a ladder for you. In our experience, they'll typically work for pizza and Japanese whiskey. If all else fails, you could get a similar effect by tying layers of mosquito netting to existing trees or fencing and skip the construction altogether. Last, we used rose-gold spray paint to lend a bit of mystique to otherwise basic mason jar lanterns (spray the inside). Warm-glow LED candles provided the flame. Hang the lanterns at various heights — ambience is key.

What You Need

Eight-foot lengths of wood	Ladder	String lights (for decoration)
Screw gun	Mosquito netting	Rope or twine, clamps, clips, clothespins (optional)
Outdoor decking screws	Tacks	

PICNIC SHELTER CONSTRUCTIONS

Birch is often used to build temporary gazebos or chuppahs for wedding ceremonies. Because the wood's not perfectly straight, it's best to start with a plan for something like a picnic shelter, but remain open to improvisation in terms of how best to layer the wood to square it up. You can see our basic plan drawn on p. 44. We overlapped the top beams with the verticals to make it less wobbly. Bottom line: the more connection points, the better. When you're done with the structure, tie it down at the corners for extra security. We recommend connecting the top joints (the connection points) by rope to stakes in the ground.

Glassware, utensils, and
 plates to mix and match

Foldout tables with benches

Mason jar lanterns

Globe lights

Handmade paper flowers

A very long tablecloth

Directions

1. Create three frame pieces first by laying the wood on the ground and screwing the pieces together. Any variation on this design should work as long as it has enough crosspieces to support the weight and keep it from shaking.

2. Get some friends together to help raise the frames and connect with beams in at least three locations for stability.

3. Stake down the corners with rope—connecting to the ground, trees, or another unmoving object.

4. Add string lights for decoration.

5. Drape some mosquito netting over the top and secure with clips and tacks!

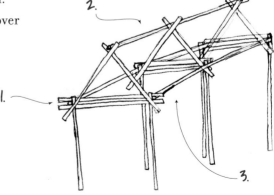

Yeah, We're Doing This (for Adults)

> 1 oz. homemade lavender vodka (steep 1 teaspoon food-grade
> dried lavender in 8 ounces vodka for two days)
> 1 oz. gin
> ½ oz. elderflower liqueur
> ½ oz. dry vermouth
> orange and Meyer lemon bitters to taste

Place the vodka, gin, liqueur, vermouth, and bitters in a large mason jar, multiplying the recipe to suit the number of guests. Stir gently and allow the mixture to chill in the refrigerator for thirty minutes before serving. Keep the mixture stored in a dark, cool place or in the refrigerator for up to two weeks. Serve cool or at room temperature.

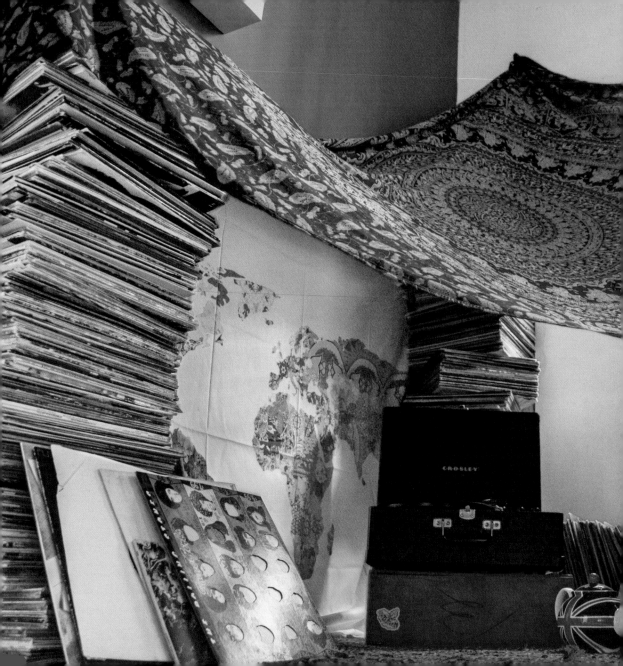

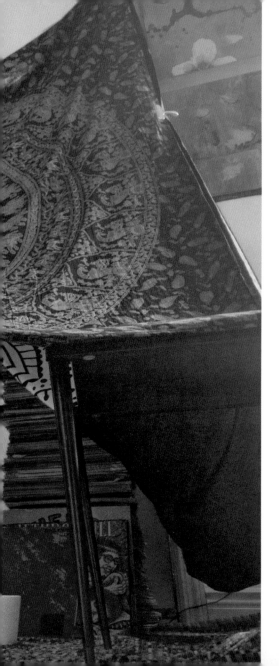

Listening
STATION

FOCUS ON
ONE PIECE OF
ART AT A TIME

Okay, kids. Not so long ago there were these vinyl pancakes that had music on them. You'd listen to full albums at a time, just the way the artist intended. An album is a collection of songs arranged in a certain order. Songs are what you hear on the radio. You know what a radio is, there's one

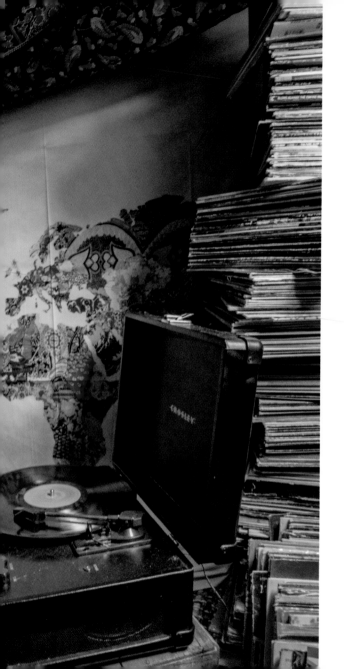

in every car. A car is what people drove before the hovercraft. Yes, people actually had to drive themselves.

Tips + Tricks

A portable record player is a must, and you can get one on the super cheap now. The most important thing is to find a quiet spot where you can blast music. Raid your family's record collection or the under $5 bin at your local shop and stack the ones you might not get to along the walls. Attach some funky tapestries to whatever you can—couch, wall, dresser. Make a cave.

What You Need

Rope or twine, clamps, clips, clothespins

Pushpins or sticky hooks

Colorful tapestries, fabrics

Records

Record player

What to Include

Union Jack teapot

Hours to stare at nothing

Headphones (optional)

Directions

1. Find a choice corner of your room to place a portable record player and records. Stack 'em high.
2. Hang tapestries along the walls, using pushpins or sticky hooks.
3. Drape fabric over the top edges of the tapestries and records to create a ceiling. Tie rope or twine to two corners and connect them to high points on the wall.
4. Tie rope or twine to the two unfastened corners of the ceiling and extend outward, connecting to furniture or other unmoving elements in the room.
5. Pull your favorite LP and crank the volume to 11.

3.

4.

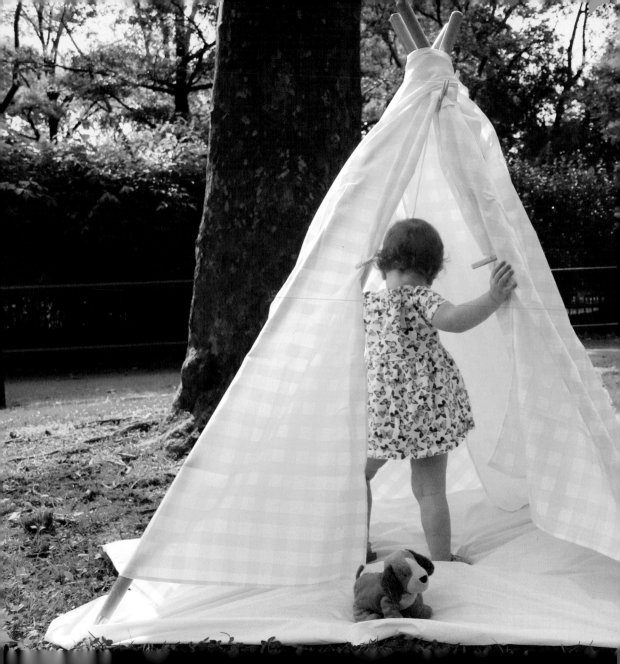

12

Sunday IN THE *Park* WITH AGNES

WEEKENDS WERE MADE FOR LITTLES

Hello, tall people who feed and clothe me. I would like a blanket fort. I would like it sized for me personally, of a color befitting my outfit, and artfully curated with my favorite toys du jour. It should be built in a public place so

as to maximize the envy factor among passing strollers. You may bring along a selection of pickles for my consumption. You may totter alongside me as I charm complete strangers. Please do not interrupt as I form psychic connections with squirrels. I'm sorry, did you say cookie?

Tips + Tricks

Four broom handles, a couple of gingham tablecloths, something waterproof to cover the grass, and you have the perfect kids' fort to take anywhere. We wrapped the fabric around the structure and attached it with clothespins. This one's quick and painless to execute, and reinforces that whole mom and dad as superheroes vibe every parent seeks to cultivate. Works in the park, works on the beach, works in the playroom. All you need is a Sunday free.

What You Need

Waterproof tarp or blanket	Rope or twine, clamps,	Tablecloths
Broom handles	clips, clothespins	

What to Include

Toys	Picnic basket with good food and snacks	A shady spot

Directions

1. Lay out the tarp or blanket.
2. Push the ends of the broom handles into the grass.
3. Tie the tops of the handles together with rope or twine.
4. Wrap the tablecloths around the broom handles and drape them down to cover the support structure.
5. Leave an opening and use clothespins to secure the fabric in place.

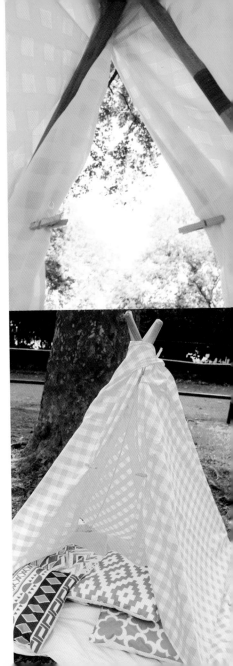

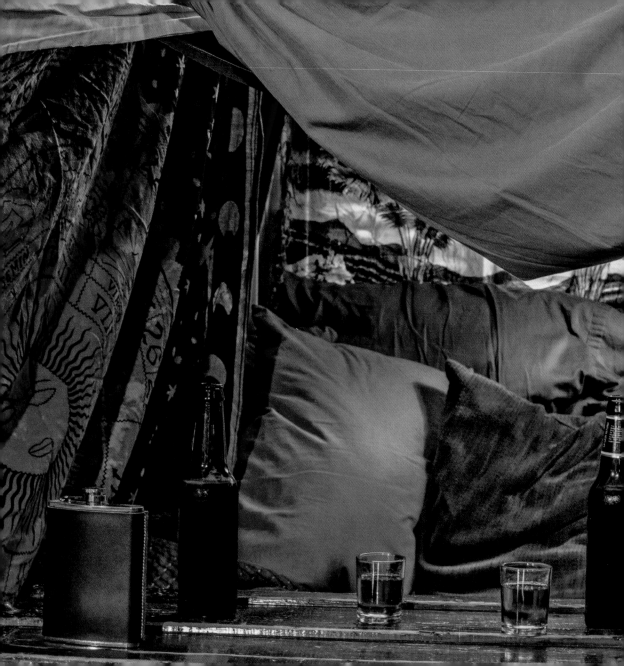

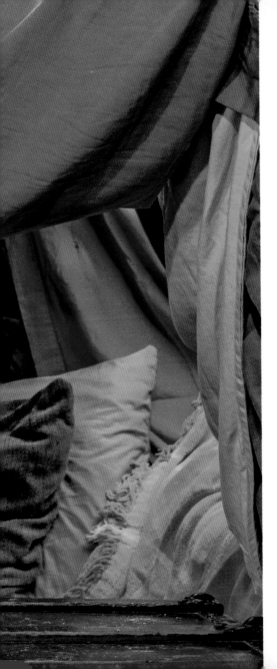

AN
Unmovable
FEAST

JUST GTF OUT

This one is for the dudes. The ones who love Hemingway and nap unapologetically. The ones who don't concern themselves with patterns or color because blankets are blankets. They all go together. Now, leave me to brood in my man cave until I get sleepy and dream of sea otters holding hands. Er,

I mean the Old West. Saloons and shootouts. Man stuff. Where's my favorite pillow?

Tips + Tricks

Keep it simple. Grab all of the blankets. (It helps if they're clean.) Secure two ropes to a window or other fixed point over a couch and tie them off across the room. Throw blankets on top and call it done. And don't worry: this one might feel like a cave inside but it's still big enough for bros, or anyone else, to spread out.

What You Need

Rope or twine, clamps, clips, clothespins	Windows or other fixed points	Couch
		Blankets, sheets, pillows

What to Include

Beer	Flask	No judgments

Directions

1. Slide your favorite couch beneath a window and tie two ropes high to either side of the window frame. (If you live somewhere without windows, choose two fixed points high on the wall and consider moving to a better place.)

2. Extend the ropes out and downward, connecting to furniture or other unmoving elements in the room. Keep the space between them wide enough for the number of people you want to fit.

3. Drape blankets and sheets over the top and down the sides, and use clips to achieve the desired shape.

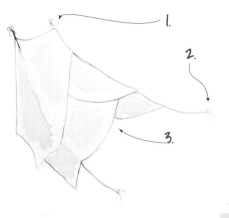

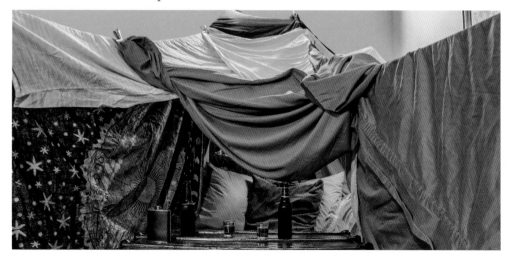

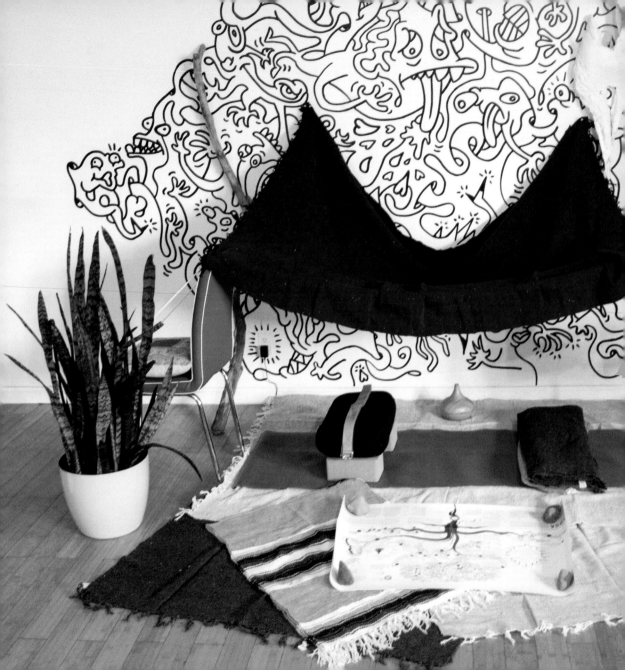

Om SHANTI

STRETCH + STRENGTHEN YOUR SOUL IN STYLE

Upward dog. Downward dog. Maybe some child's pose. Some happy baby. Savasana sounds perfect right about now. Surround yourself with pillows. A blanket or two. Lavender. Eucalyptus. Soft dappled sunlight and a skinny mirror. We can see why people get into this.

Tips + Tricks

This fort is one of the easiest to execute. All you need is a couple of chairs to act as supports and to spread your yoga mat and props underneath. Take care that the chairs don't tip inward as you place blankets on top—adding some weight to the chairs can help. As with everything, the key to this one is location, location, location, so make sure to search out a quiet spot to call your own.

What You Need

Rope or twine	Two chairs	Yoga mat and props of choice
Clamps, clips, clothespins	Yoga blankets, pillows	Pushpins

What to Include

Essential oil diffuser	Local art as a background	Tree map of yoga practices

Directions

1. Place your yoga mat with the long edge stretching along a wall.
2. At the far ends of the mat, position two hard-backed chairs facing away from each other.

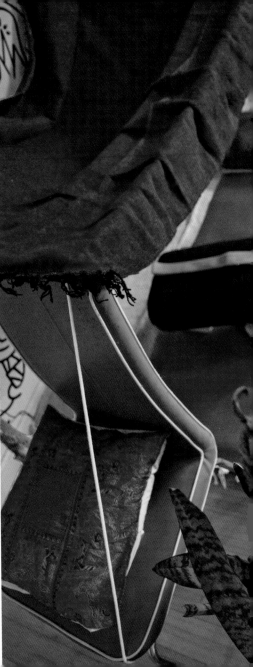

3. Tie a long piece of rope to the front leg of one chair, then run it over the backs to connect to the opposite chair's front leg. Pull the line taut, then coil around the adjacent front leg. Return the rope over the backs to connect to the first chair's remaining front leg. Pull the line taut and tie off — there should now be two lines of rope running parallel between the chairs. Take care to avoid the chairs tilting inward during this process.

4. Hang a yoga blanket over the ropes and chairs to create a canopy.

5. Using pushpins, raise the side of the blanket closest to the wall. Use clips to create desired shape.

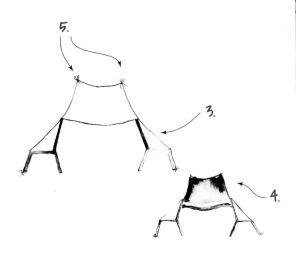

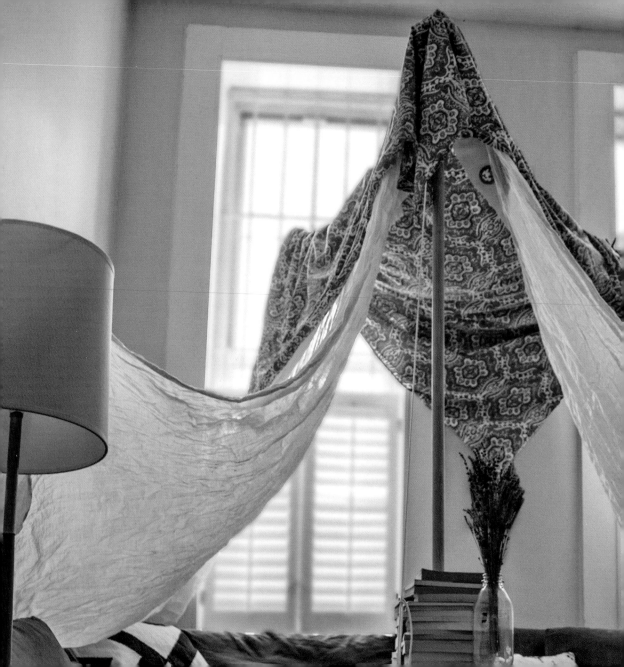

15

High Tea
ON THE
HIGH SEAS

WHY WOULD YOU WANT TO GO ANYWHERE?

So you're landlocked. No matter. Hoist the anchor. Trim the sails. Something about a jib. Heat that kettle until it whistles a sea chanty. Steep that special tea you've been saving. Add honey. Invite a friend. Breakout the travel-size chess board. Journey starts now. Queen's knight to F4.

Tips + Tricks

Getting height in your blanket fort, at least enough for adults to feel comfortable, can be challenging. This was the first fort we made, and so the eight-foot dowel makes its one and only appearance here. Keeping it sturdy required a lot of haphazard knots. We secured this "mast" between two stools, then wedged the stools between two parts of a couch, then strung support ropes to the tops of two window grates to keep the whole structure from falling over as we added the weight of fabric. It's an exact science— perhaps best performed at sea where no one can watch you struggling.

What You Need

Rope or twine, clamps, clips, clothespins

Eight-foot-long dowel

Two stools

Heavy chairs and a couch

Blankets, sheets, pillows

What to Include

Tea

Games

Books

Lavender

A healthy disregard for established knots

Directions

1. Stand the dowel up between the stools, then lace rope back and forth around the dowel and the stool legs for stability.
2. Tie rope to the top of the dowel and connect to two pick points on a wall, window, door, or furniture.
3. Push heavy chairs and a couch around the stools to stabilize.
4. Hang blankets over the ropes and to the floor.
5. Cap the fort off with an accent blanket for the roof.

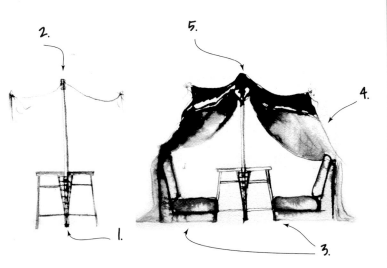

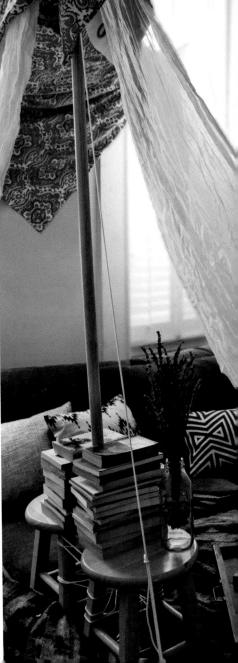

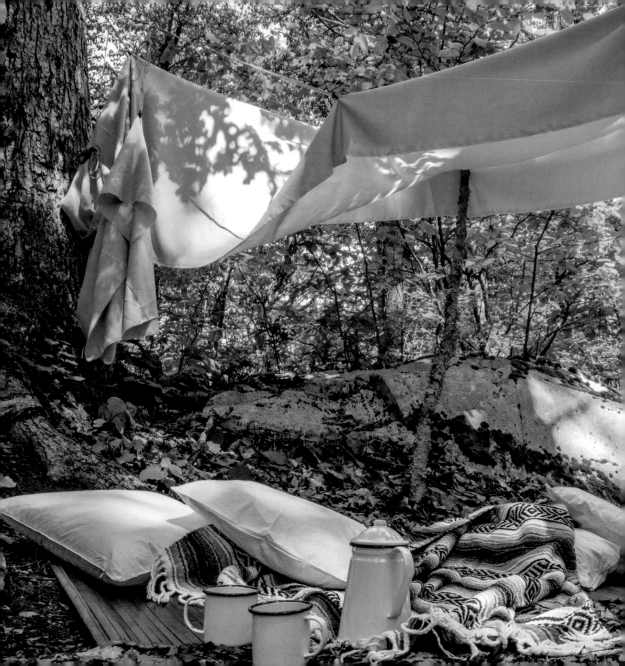

Bears Love BREAKFAST

GOOD MORNING FROM THE HUNDRED-ACRE AWESOME

Camping isn't all about chopping wood, scaling mountains, and leaf-peeping. Start your day with a percolator and some dark roast coffee—brewed double strength to suit your inner wild animal. Add some skillet eggs or keep it simple with oatmeal, fresh berries,

and honey. Better yet, just stick with the honey. Right out of the pot. Don't get your snout stuck, though. And watch out for Heffalumps and Woozles.

Tips + Tricks

This one's great for a quick morning project while camping. First, choose a cozy spot under some trees. String up the canopy blanket—leaving the ends drapey—and prop it up with a couple of long sticks. Use clips to create an awning. Spread some choice blankets or a beach mat on the ground and lounge the day away.

What You Need

Trees	Rope or twine, clamps, clips, clothespins	Blankets or beach mat, pillows
Sticks, 3 to 5 feet long		

What to Include

Coffee made your favorite way: French press, pour-over, percolator, whatever!	Camping mugs	Binoculars to spot pic-a-nic baskets

Directions

1. Find two trees set five to ten feet apart.
2. Tie lengths of rope between the trees at differing heights.
3. Using clips, attach the blankets to the ropes at various points.
4. Prop sticks underneath the blankets to stretch them outward and create more space.

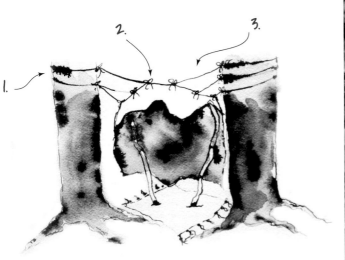

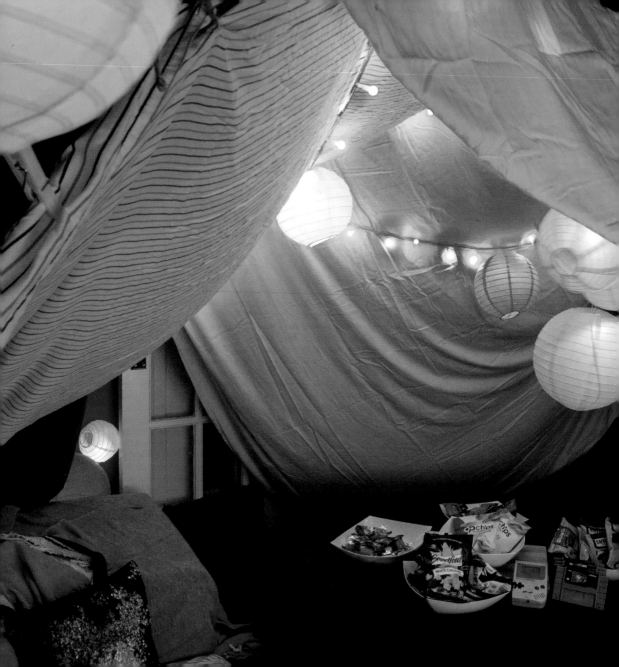

RPG OMG

THROWBACK SLUMBER PARTY IS IN FULL EFFECT

Break out your old gaming systems and call up your friends. Memorize your cheat codes and order some pizza. Extra cheese and meatballs. Salad on the side because we all know what gluten does. No need to check with Mom, this living room's all your own. Yeah, we can eat candy as an appetizer. Bite-size

means fewer calories. Just look at Yoshi. Two decades and he hasn't gained an ounce.

Tips + Tricks

Remember us mentioning that we wished we had bought the aluminum rod tent poles earlier in the process? This fort proves why. We were able to turn an entire living room into a blanket fort suited for six or seven people in less than an hour—and fifteen minutes of that was spent trying to find a second SNES controller. The tarp we laid down had grommets in the corners, allowing us to insert the poles and tape them in place. We crossed the poles in a standard tent construction and tied them together in the middle, then used rope to secure each pole to high pick points in the room—door jambs, windowsills, anything that's unlikely to move. It's important to go high with the pick points to keep the poles from bending inward under the weight of the blankets.

What You Need

Tarp with corner grommets	Blankets, sheets, pillows	Rope or twine, clamps, clips, clothespins
Aluminum rod tent poles	Gaffer tape	

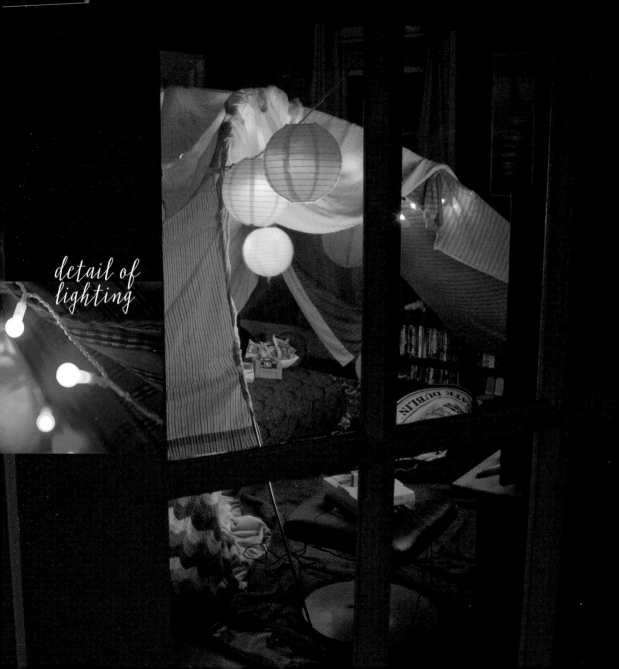

detail of
lighting

What to Include

Paper lanterns

Multicolor string lights

Throwback video games

Snacks, snacks, and more
snacks

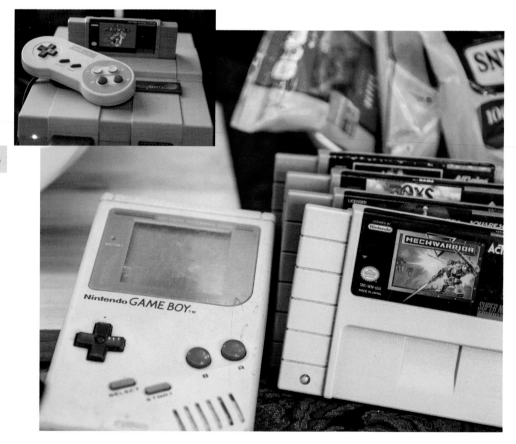

Directions

1. Lay down the tarp.
2. Put the ends of the tent poles into the grommets like you're pitching a tent, securing with tape so they don't pop out.
3. Tie the poles together in the center, then add some ties from the poles to pick points for stability.
4. Toss blankets and sheets over the top of the structure and adjust placement with the help of a friend.

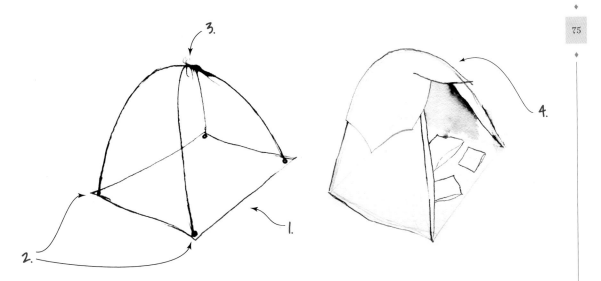

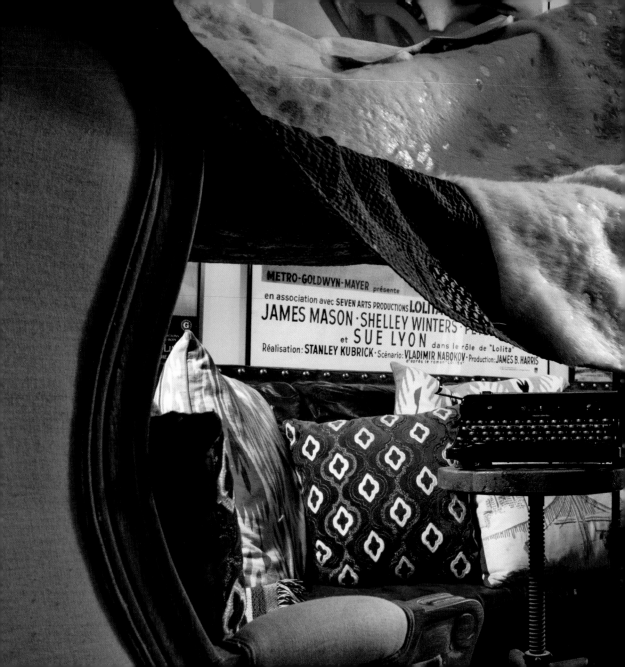

Blank Page,
BUSY MIND

GET COMFORTABLE.
BESTSELLERS
TAKE TIME.

Imma write the Great American Novel. I have ideas and I have taste. I even use a typewriter because rhythm is essential. Tonight is going to go down in history. Going to surround myself with Shakespeare. Coffee might be good. Maybe some music. Maybe some blankets. Wonder what everyone else

is doing. How is it midnight already? Okay, complete focus from here on out. No internet. No distractions. Just need one glass of bourbon to get me started.

Tips + Tricks

This one works best when you just pull all of your furniture together to create your own writing cave. We placed a spare rug on the top. Surround yourself with inspiration and cut yourself off from the rest of the world. All you need is a little bit of rope to tie everything together.

What You Need

Big comfy couch	Rope or twine, clamps, clips, clothespins	Blankets, sheets, pillows, rug
Additional furniture		

What to Include

Inspiration	Crumpled napkins with brilliant ideas	Your favorite published prose
Writing utensil of choice		Coffee, tea, or bourbon neat

What to Leave Outside

Distractions

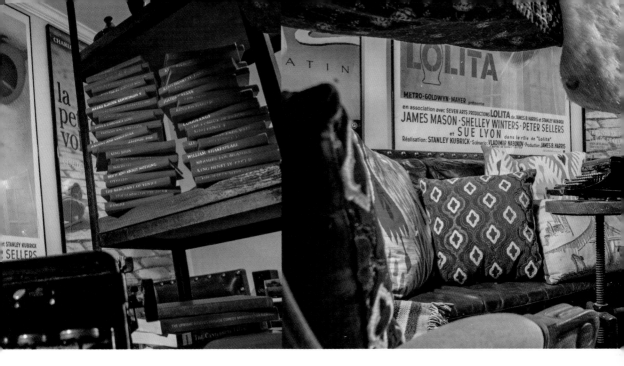

Directions

No steps needed! Push all your furniture together and tie ropes at the high points to support blankets.

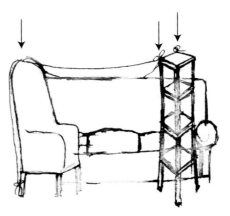

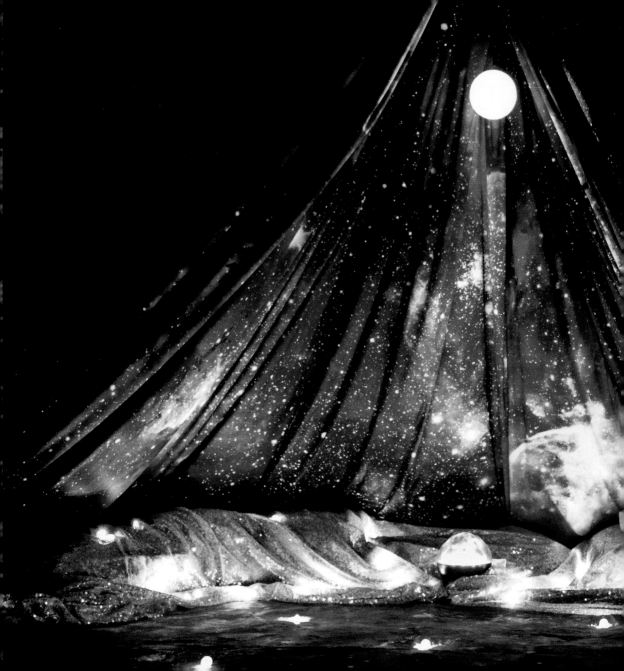

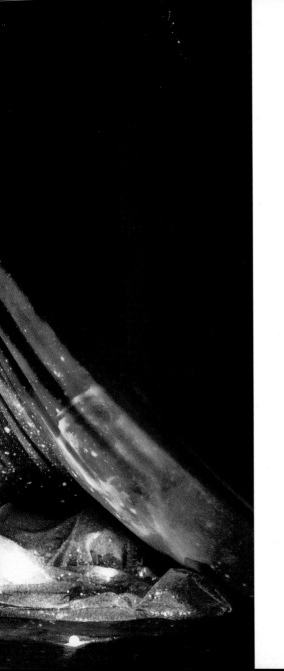

Ground
CONTROL

FORGET NETFLIX + CHILL. LET'S GET LOST TOGETHER.

Seeking potential life mate who remembers when Pluto was a planet. Must be up to date on all operating systems and ready to travel should interstellar exploration become a thing. Glasses preferred. Hygiene a plus. Tell me your favorite *Doctor* and I'll tell you mine. Full disclosure: I have cats.

Tips + Tricks

The key to this one is finding blankets that give the effect of being in a galaxy far, far away. Once you've sourced everything, spread a small area rug on the floor as the base. With one end of a rope, tie sheets together at the top with star patterns facing inward. Swing the other end of the rope over the nearest crossbeam or seriously sturdy light fixture. Raise to optimum height, fan out the fabrics, clip to the base at the corners, and you're there. We used balloon lights and sequins to heighten the starry effect. Some sort of rotating disco ball or a pocket-size LED projector can bring it to the next level.

What You Need

Rope or twine, clamps, clips, clothespins

Galaxy sheets

Sparkly fabric

Small area rug

Balloon lights

What to Include

Disco ball or moon light

Light projector

In-flight magazine

A sense of adventure

Directions

1. Spread a small area rug.
2. Tie together galaxy sheets with star patterns facing inward, leaving enough rope to complete next step.
3. Toss the other end of the rope over an overhead beam or attach to a sturdy light fixture. Raise sheets to desired height and tie off the rope, connecting to furniture or other unmoving elements in the room.
4. Fan out sheets and tuck around area rug.
5. Scatter balloon lights.

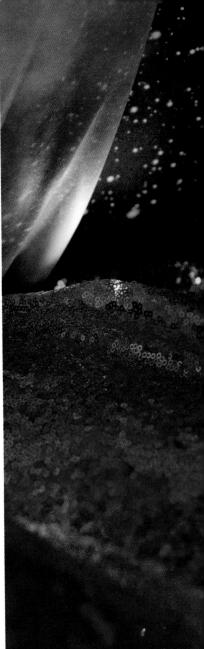

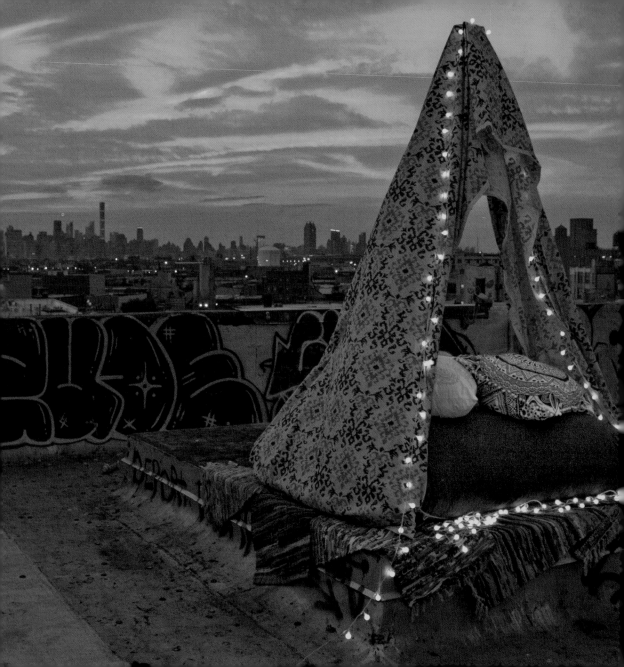

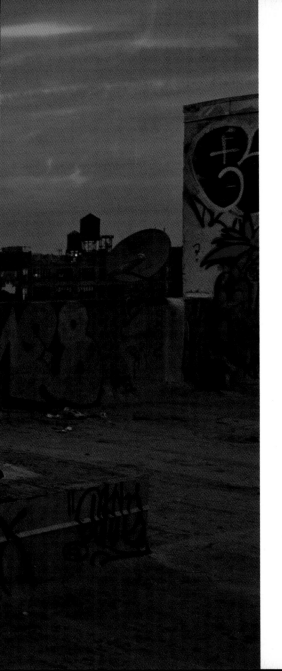

Skyline VIEW

DON'T FORGET THE ROSÉ

This spring, your mission is to hunt down that special someone with a generous heart, sharp mind, incredible body, and rooftop access. This person will ideally have eyes you can get lost in and a bloated bank account they don't mind spending on you. They should have an adventuresome spirit that unlocks hidden parts of

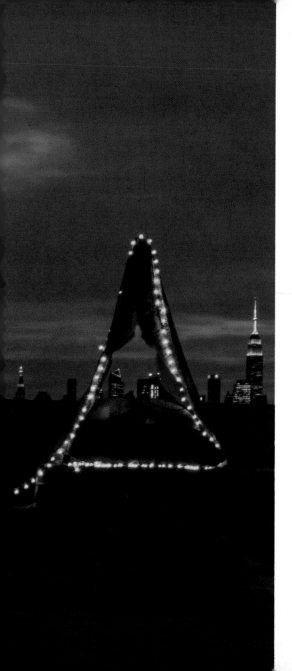

your soul as well as the city you've come to call home. Or, at the very least, a clutch rooftop spot that will carry you through summer. Everything else is more or less optional.

Tips + Tricks

The biggest element to this fort's success is using a giant floor pillow to weigh the whole construction down. We tied some telescoping tent poles together at the top, then connected their legs with rope strung diagonally underneath the giant pillow to withstand the rooftop wind. No shame if you get knocked down a few times—for us, making this fort took a lot of trial and error. Keeping an open frame allows you to focus on the view, and keeping an open mind allows you to enjoy it if the wind knocks one (or more) of your blankets out of place.

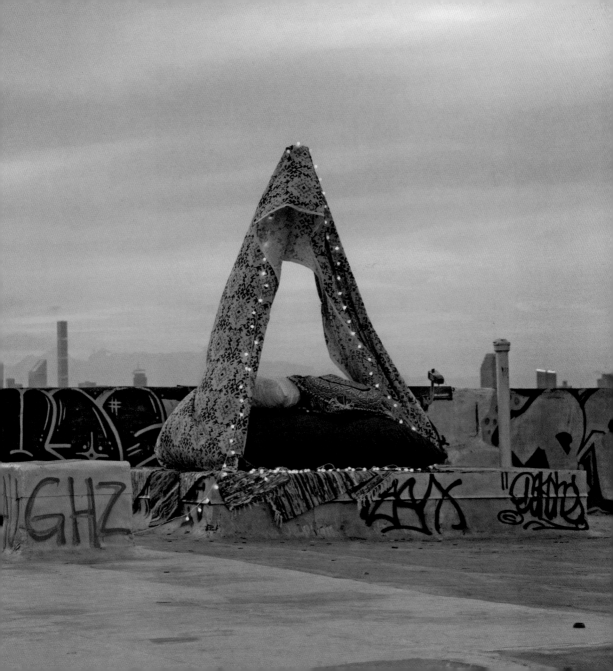

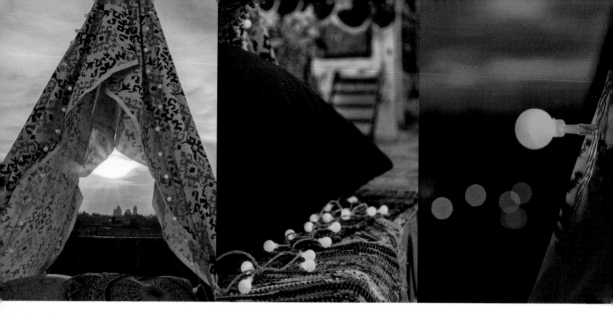

What You Need

Four telescoping tent poles

Giant floor pillow (or bean
 bag chair)

Blankets, pillows

Rope or twine, clamps, clips,
 clothespins

What to Include

String lights

A great view

Rooftop street art

Something
 to sip on

Directions

1. Extend the tent poles and tie them together at the top with rope.
2. Loosely tie their legs together in an X pattern.
3. Place the giant floor pillow over the lower set of ropes to hold down the fort.
4. Drape a sheet over the tent poles.

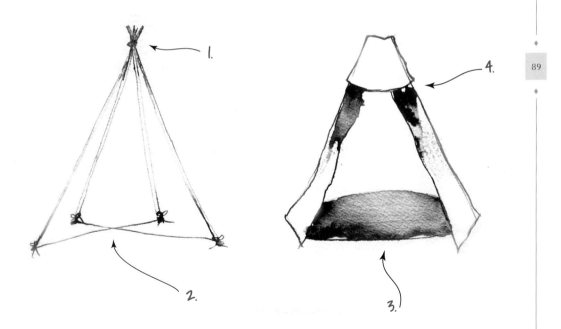

Lazy MILLENNIAL

NO ASSEMBLY REQUIRED.

Or, as an alternative, you could not get hung up on this whole achievement thing. Pillows and blankets are just as satisfying when piled high on a couch as artfully curated overhead. Ideally suited for midmorning cups of coffee brewed by your parents before they leave for work. BTW, isn't this job market the worst?? Good thing it's the golden age of television. No, not the actual TV, obvs. Log on. Unplug. Enjoy the fabric softener.

ACKNOWLEDGMENTS

The authors wish to acknowledge the shiny, happy creatures without whose contributions this book could have never taken flight.

Our rockstar editor Emma Brodie and the entire team at William Morrow: Liate Stehlik, Lynn Grady, Cassie Jones, Susan Kosko, Bonni Leon-Berman, Alicia Tatone, Andrea Molitor, Kaitlin Harri + Andrew Gibeley.

Our co-conspirators in childlike creation: Angel + Erik Grathwohl; Hannah Huber + Will Farrell; Agnes June Berger, Melissa Lusk + Matt Berger; Lili Vasileff + Alexandra Kressen; Hilary Austin; Melissa Hunter Gurney + GAMBA Forest; Abby Ronner; and our rotating horde of blanket fort cohabitants.

And our critters Charlie, Pepper + Porter, who have yet to sign releases for this book.

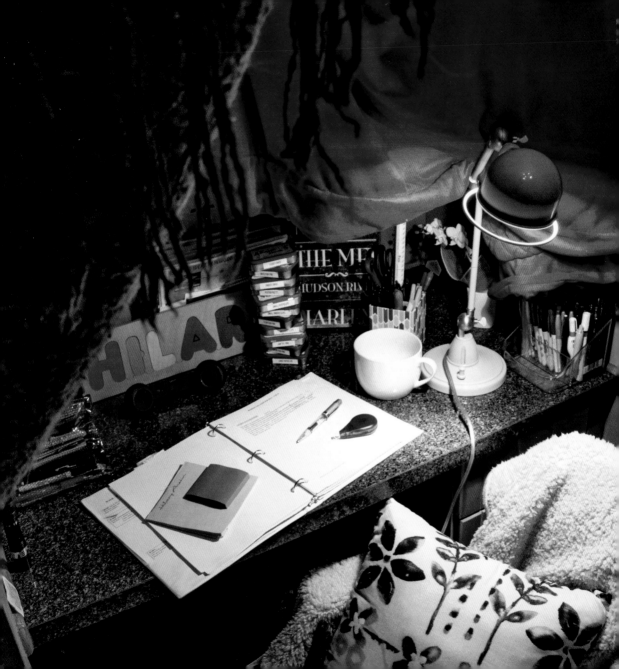

Grackle + Pigeon is a wife-and-husband creative team based in Brooklyn. Together, they have worked across print, theater, video, and the web to bring artful concepts to fruition. Their work can also be found in the independently published novels *Dahlia Cassandra* and *Concrete Fever*. Their philosophy is that everyone needs a little magic in their realism.